THE MYSTERIOUS DEATH

OF TOM THOMSON

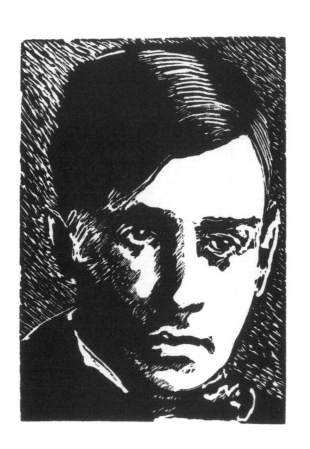

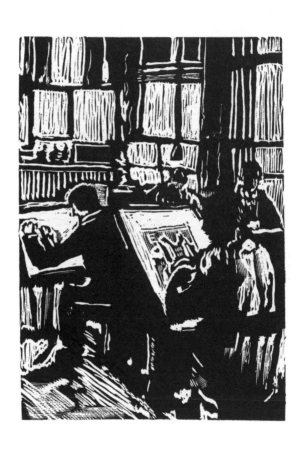

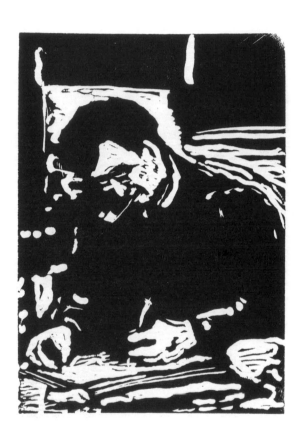

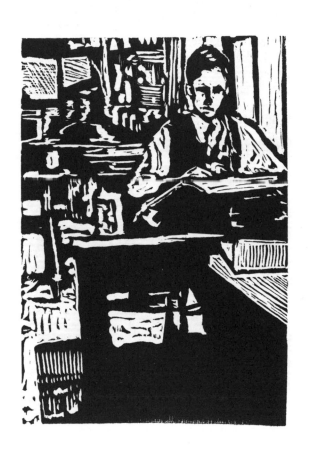

THE MYSTERIOUS
DEATH OF
TOM THOMSON

A WORDLESS NARRATIVE TOLD IN ONE HUNDRED AND NINE WOODBLOCK ENGRAVINGS

GEORGE A. WALKER

The Porcupine's Quill

Library and Archives Canada Cataloguing in Publication

Walker, George A. (George Alexander), 1960–
 The mysterious death of Tom Thomson : a wordless
narrative told in one hundred and nine woodblock
engravings / George A. Walker.

ISBN 978-0-88984-348-6

 1. Thomson, Tom, 1877–1917 –– Comic books, strips, etc.
2. Thomson, Tom, 1877–1917 –– Death and burial –– Comic books,
strips, etc. 3. Painters –– Canada –– Biography –– Comic books,
strips, etc. 4. Graphic novels. I. Title.

ND249.T5W24 2012 759.11 C2012-900805-2

1 2 3 • 14 13 12

Published by The Porcupine's Quill, 68 Main Street,
PO Box 160, Erin, Ontario NOB ITO. http://porcupinesquill.ca

Represented in Canada by the Literary Press Group.
Trade orders are available from University of Toronto Press.

We acknowledge the support of the Ontario Arts Council and the
Canada Council for the Arts for our publishing program. The
financial support of the Government of Canada through the Canada
Book Fund is also gratefully acknowledged.

 ONTARIO ARTS COUNCIL
 CONSEIL DES ARTS DE L'ONTARIO

 Canada Council Conseil des Arts
 for the Arts du Canada

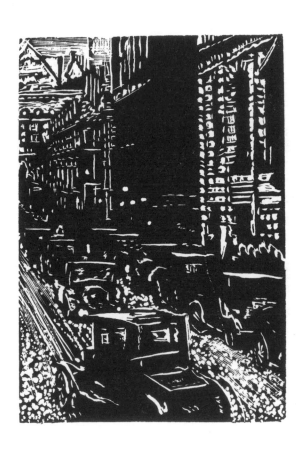

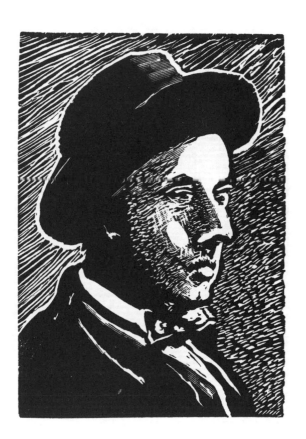

INTRODUCTION

TOM SMART

When his body was discovered in a lake in the Algonquin Park wilderness in July 1917, Tom Thomson had been missing for eight days. He disappeared while canoeing. Although the official cause of death was accidental drowning, how he actually died is a mystery even though it was reported that the corpse had fishing line wrapped around a leg and the head showed evidence of trauma. Speculation abounds either that a neighbour, Martin Blecher, Jr., murdered him, or that he fell during a drunken brawl with J. Shannon Fraser, over an unpaid loan to Fraser for the purchase of canoes.

Thomson is said to have needed the money for a new suit to wear for his marriage to Winnifred Trainor, whose parents had a cottage near where Thomson was staying in the park. Rumours circulated following the death that she was pregnant with Thomson's child. Neither of these theories was ever proven, and the wide range of speculation serves only to perpetuate the Thomson myth.

The Mysterious Death of Tom Thomson re-imagines in some one hundred wood engravings the events leading up to Thomson's tragic death and the discovery of his body. It explores the theme of death and the realization that in spite of even the greatest achievements, we as human beings are nonetheless powerless against it. The narrative is a visual elegy reflecting on the loss of a gifted artist and a man of his time fluent in the visual language of modernism, who also found solace and an artistic muse in the wilds of the Canadian bush. George Walker's engravings chart Thomson's life and

11

relationships as a commercial artist making his way in early twentieth-century Toronto, and his journeys of discovery as a painter who found creative inspiration in the hinterland of lakes and forests.

As Walker conceives it, this book also translates in a purely visual language one of the earliest known works of literature, the Epic of Gilgamesh, about an ancient king and master builder, named Gilgamesh. A story told in two parts, the first revolves around the relationship between Gilgamesh and Enkidu, a wild man created by the gods as Gilgamesh's equal. Enkidu was an innocent savage, content to live among the beasts until a trapper tamed him.

Through his friendship with Enkidu, Gilgamesh learns much about what it is to be human. He experiences love and compassion, as well as death and loss. As Enkidu rages against his own death, he fights to live. His distress at his impending death is appeased by the sun god who assures him that he will be remembered after he passes on.

The second part of the epic, focusing on Gilgamesh's sorrow over Enkidu's death, takes the form of a quest for immortality. He grieves heavily over the loss of his friend and vows to find the key to everlasting life. So, he sets out on his own journey through the underworld to learn the secret of everlasting life.

This ancient story about finding redemption in death is ultimately about the meaning of remembrance, and is also a parable of artistic creation. Expressed metaphorically, the epic advocates the reconciliation of the dual nature of the artist hero – his sensibilities as a man of his time and builder of cities, with his natural self, personified by Enkidu.

On his journey, Gilgamesh must find ways to express creatively his tremendous personal energy, but still act in a manner that accords with the limits and responsibilities imposed

upon him by his society and universe. These are the same obligations that face Walker's hero, Tom Thomson.

Walker's Thomson is a modern-day Gilgamesh. In the wordless, pictographic narrative, Walker describes the struggles and accomplishments of his artist protagonist. Like Gilgamesh, Thomson must come to terms with the gifts and talents that are his alone, and live out his vocation in both the city and the wilderness against a background of war. This is a narrative constructed around a man and his search for meaning by experiencing nature. Thomson rejects the modernism of the city, its industry and commerce, in order to find his destiny in the hinterland.

There is a larger narrative that enfolds the book that you have in your hands. It is a story that includes George Walker, an artist and wood engraver, coming to terms with the death of his own artistic double and Enkidu-figure: Tom Thomson. This book charts our author's realization that he too must learn about death and tell the tale as art to instruct all of us.

Gilgamesh is told that since immortality is for the gods alone, he should find joy in living a life worth remembering. While everlasting life is not his destiny, Gilgamesh is instructed to leave behind him a name and also the fruits of his creativity – buildings and stories – that will endure. 'I will go to the country where the cedar is felled,' he tells Enkidu. Thus, he turns his attention away from small desires to loftier aims – desires that benefit rather than harm. This is the same morality tale that Walker tells us in his suite of engravings.

In *The Mysterious Death of Tom Thomson,* the hero embodies qualities of both Gilgamesh and Enkidu. Walker's mystery teaches us what it means to be human and mortal. It also tells of the power of art to be a living witness to the true stories, drawn from a deep well of experience and myth, that unite humankind.

AFTER A BRIEF INTRODUCTION

THE NARRATIVE RESUMES

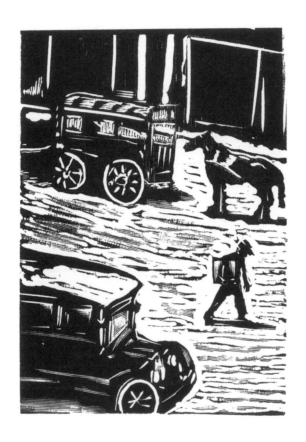

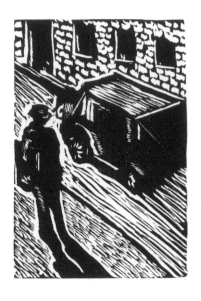

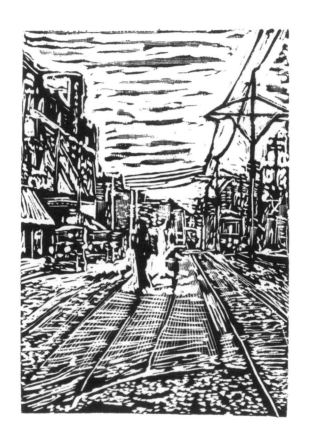

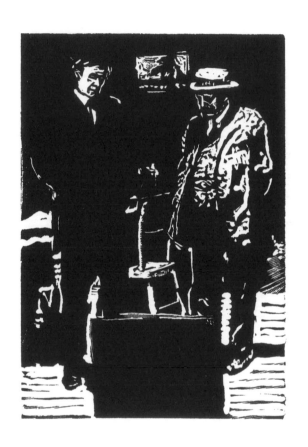

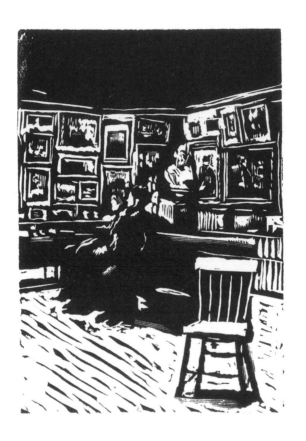

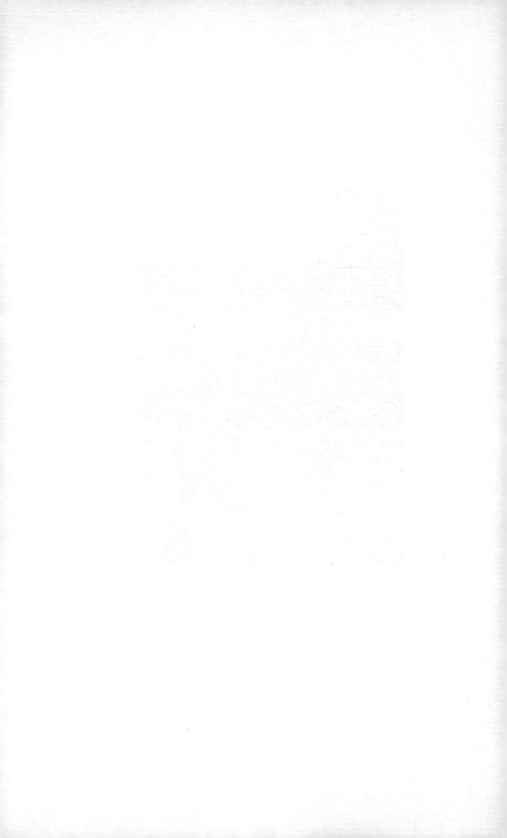

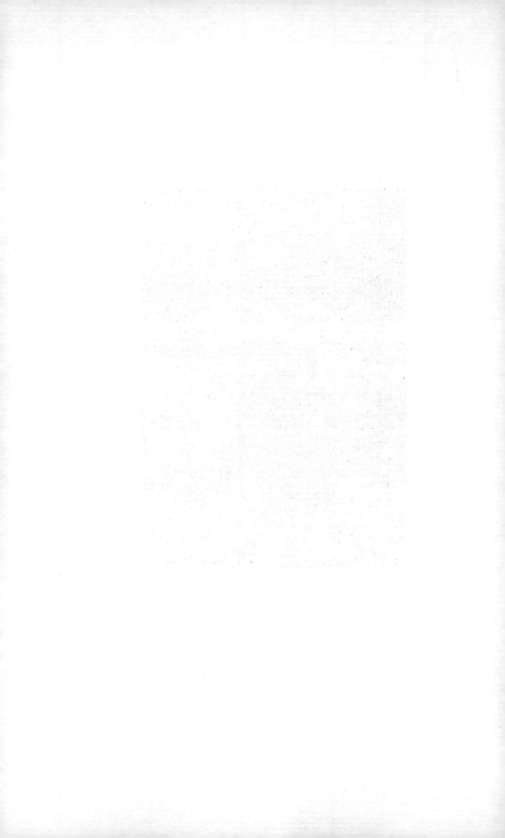

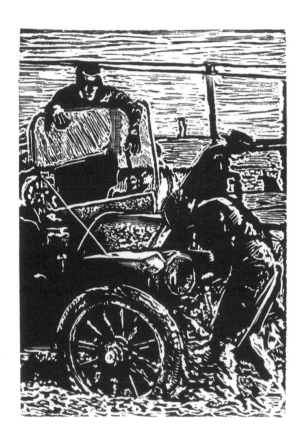

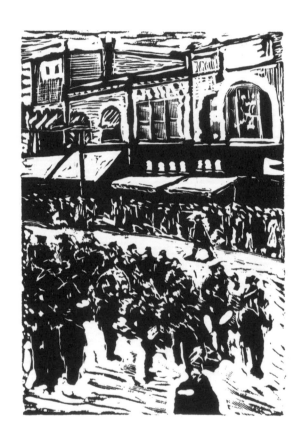

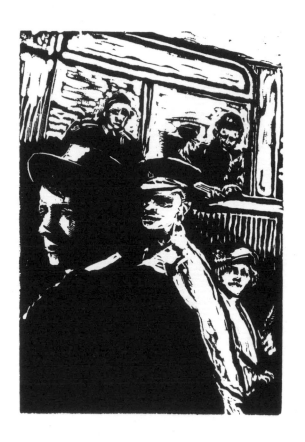

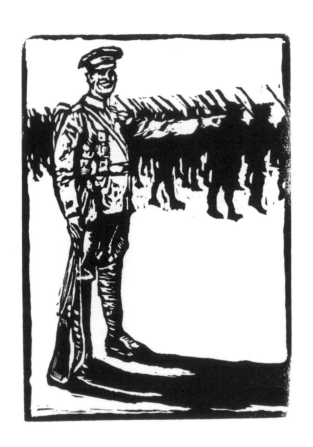

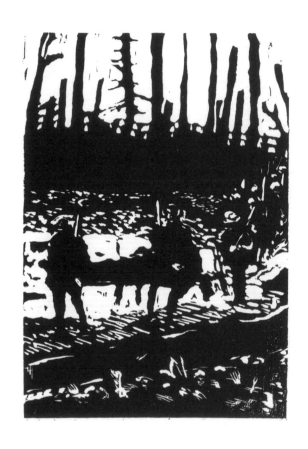

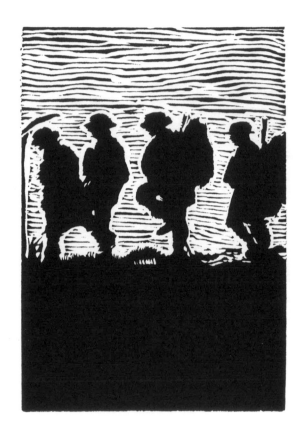

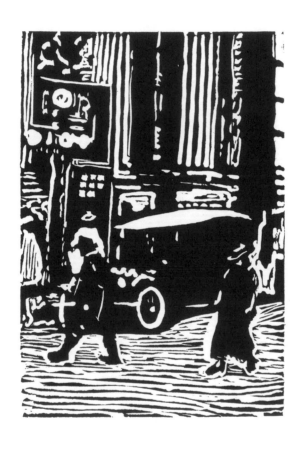

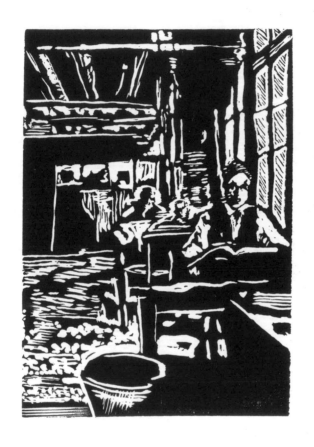

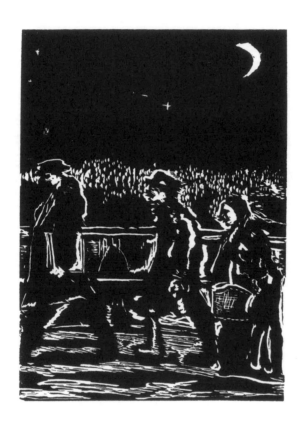

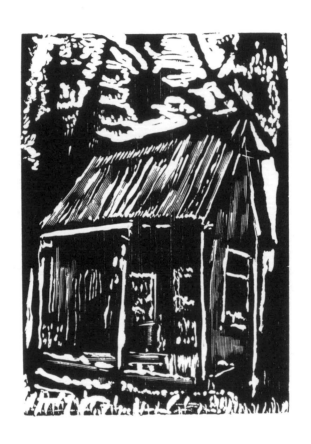

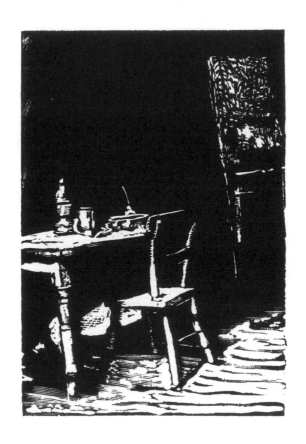

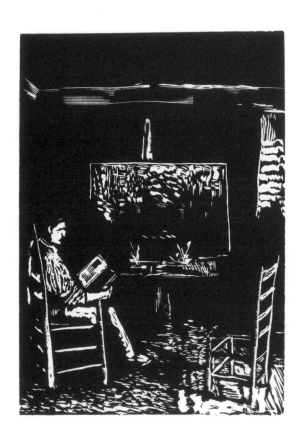

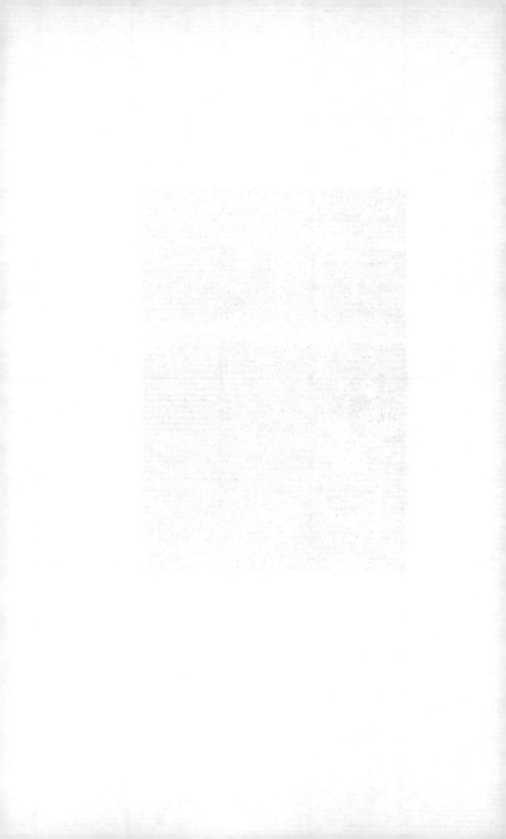

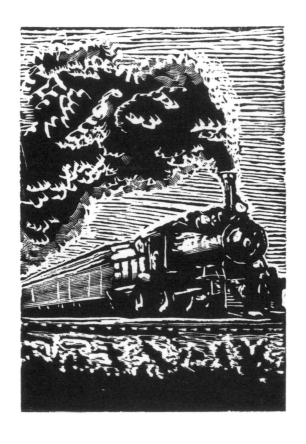

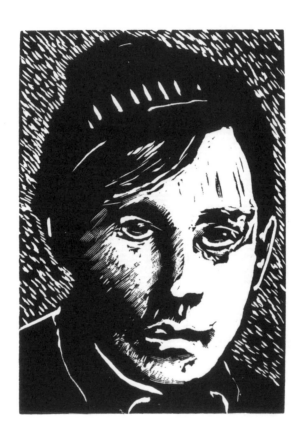

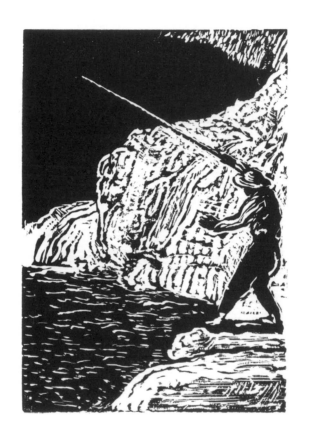

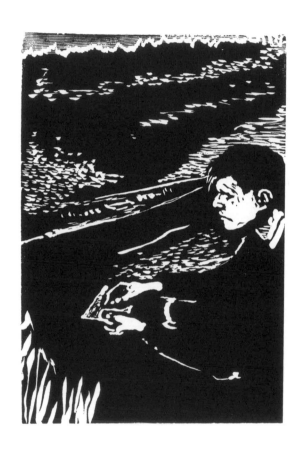

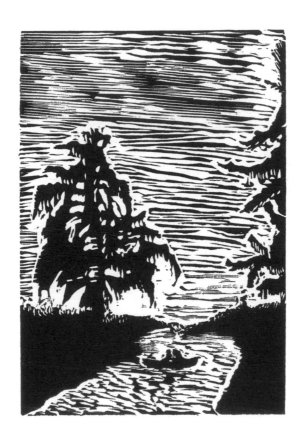

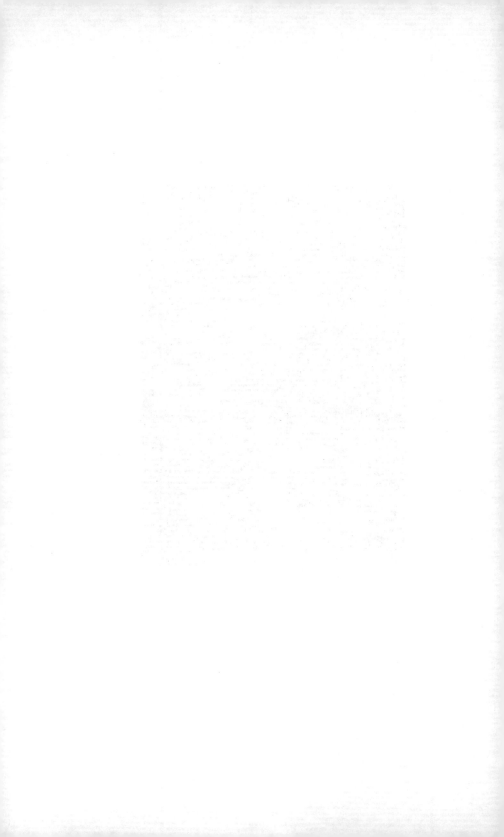

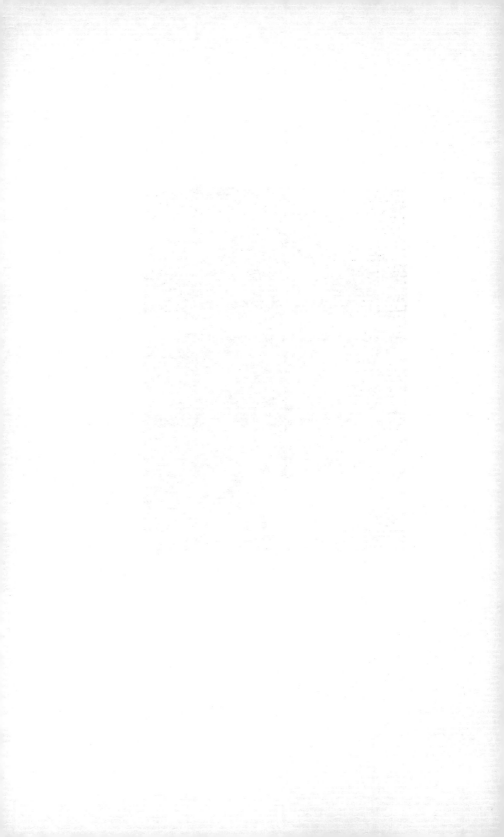

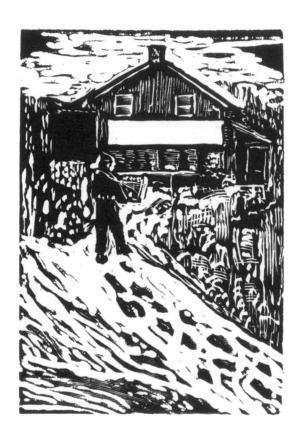

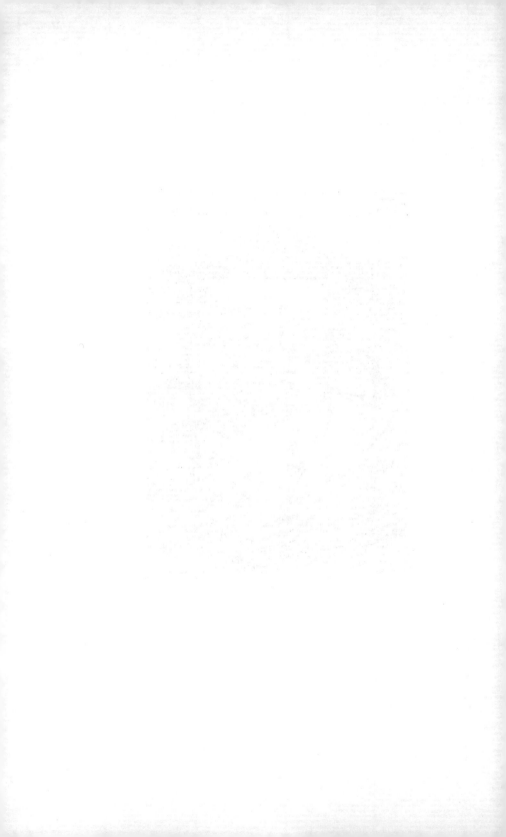

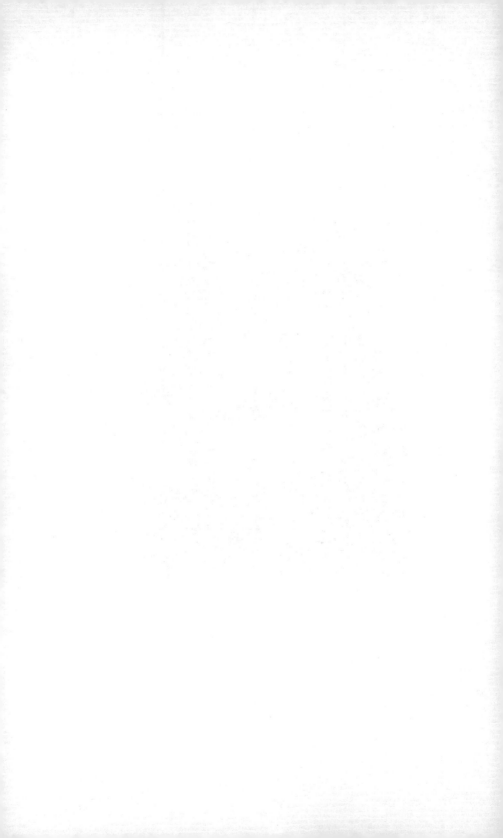

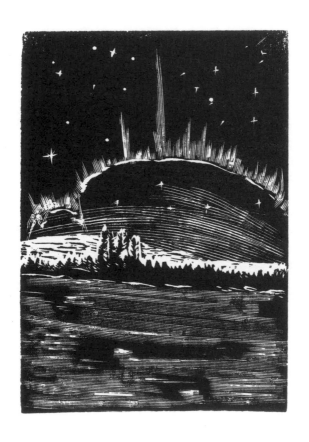

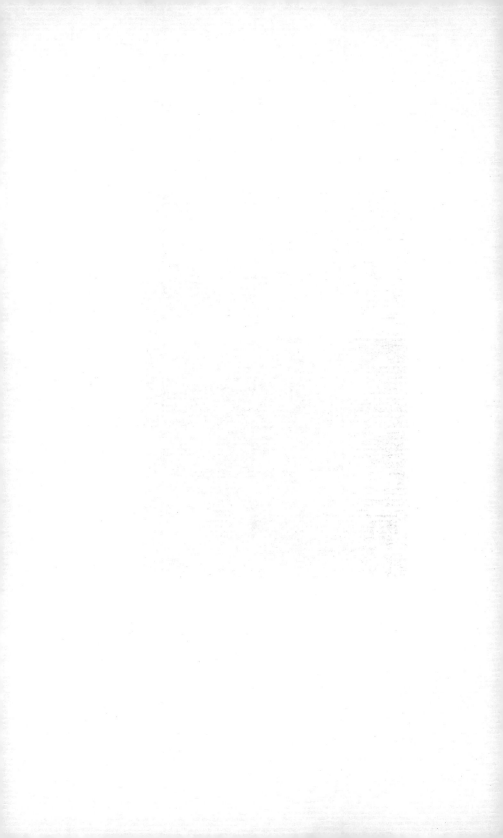

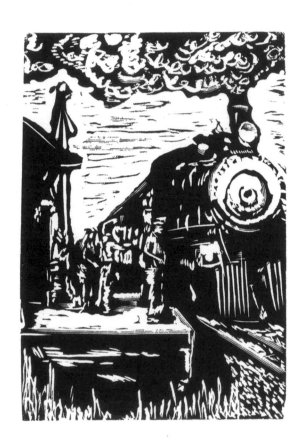

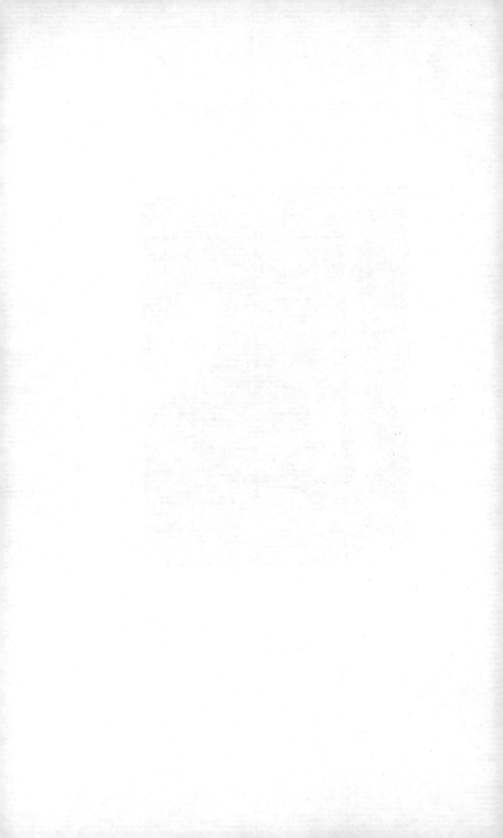

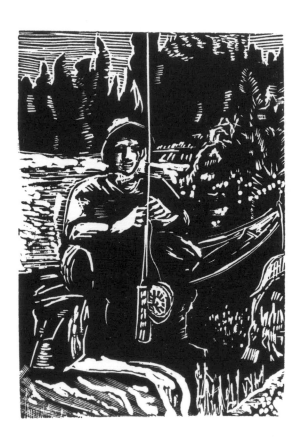

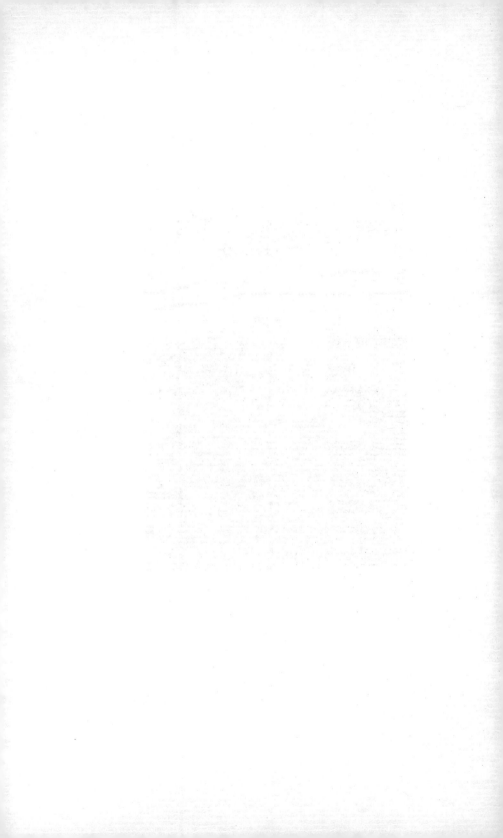

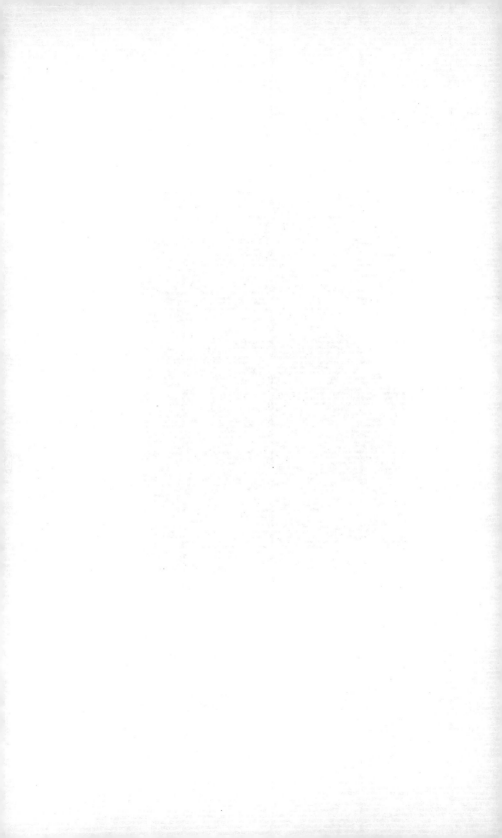

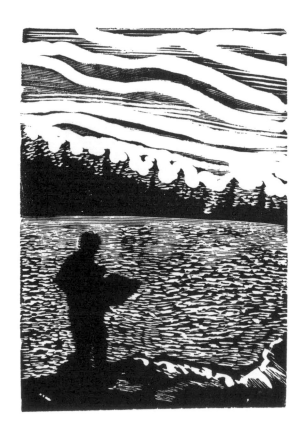

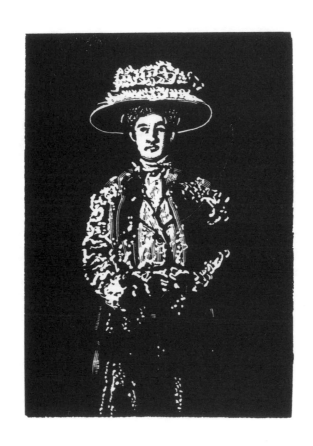

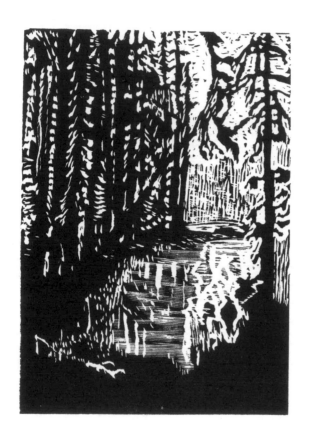

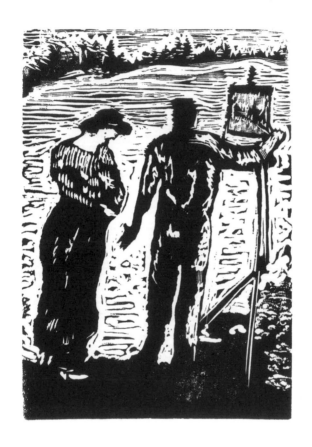

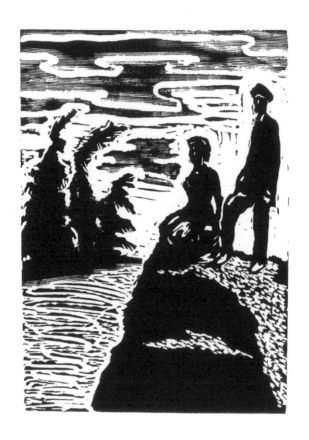

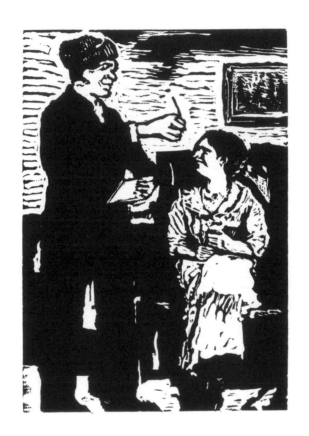

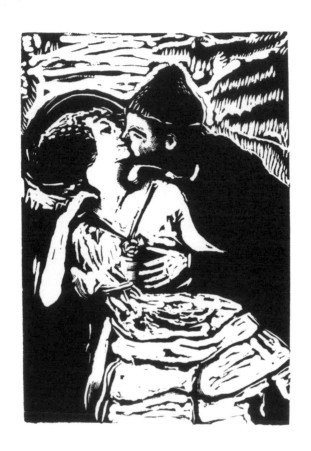

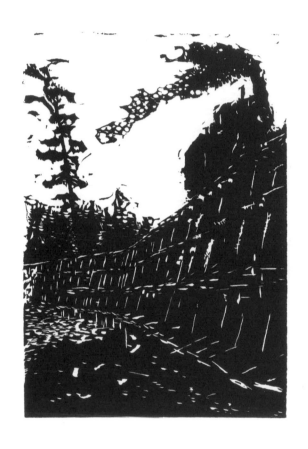

III

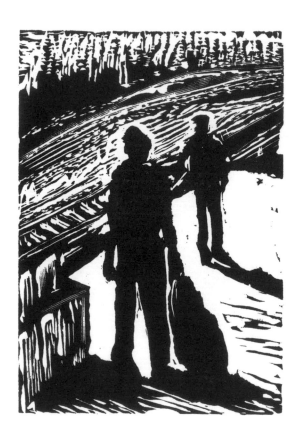

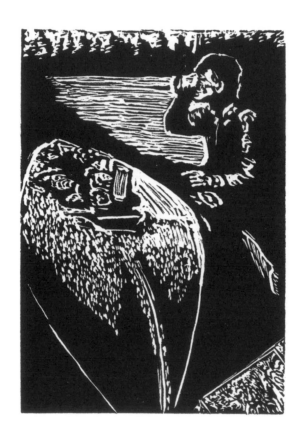

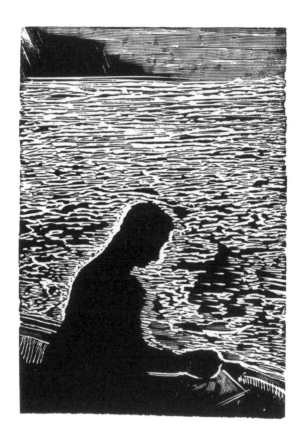

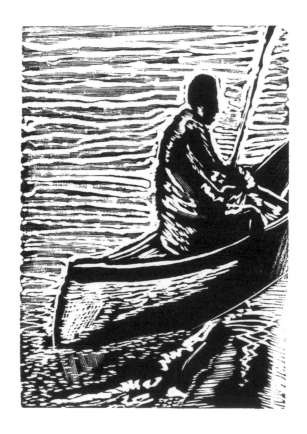

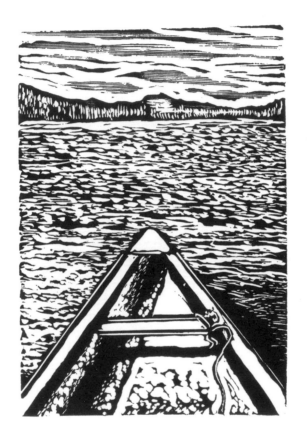

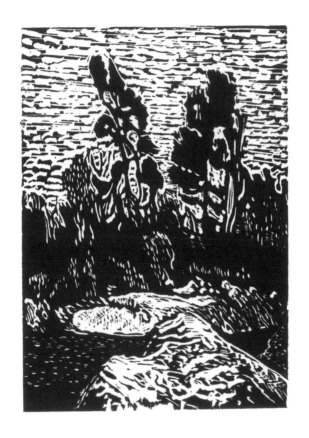

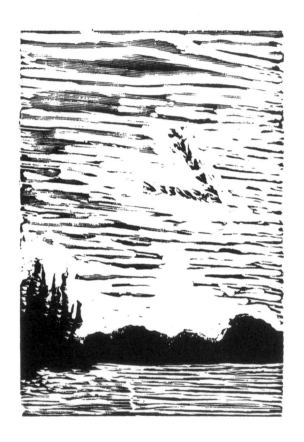

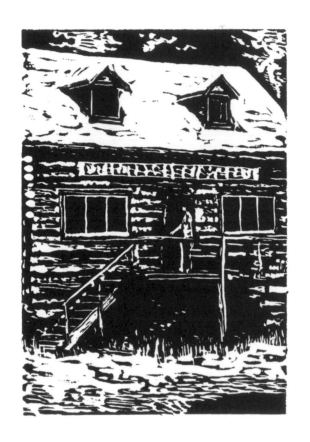

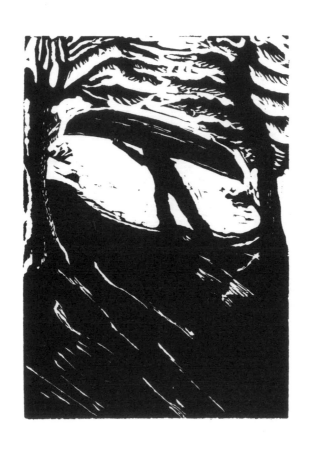

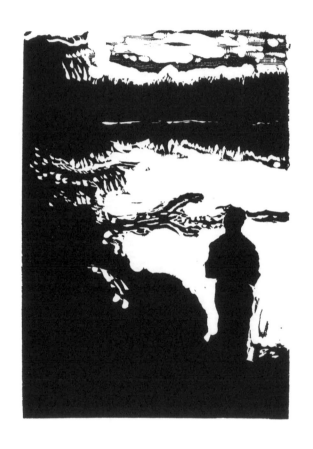

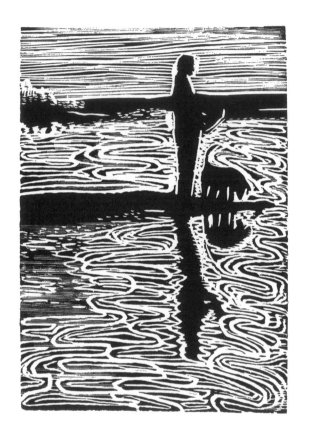

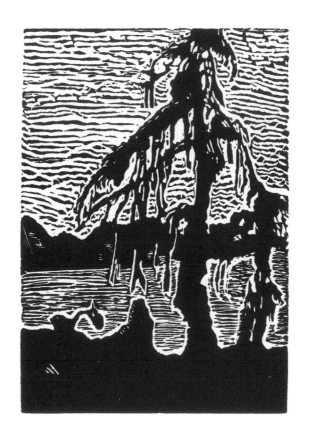

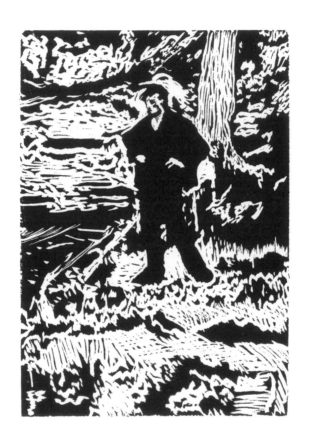

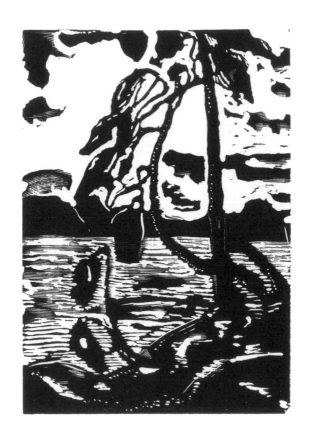

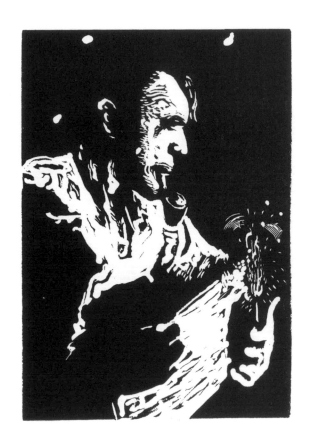

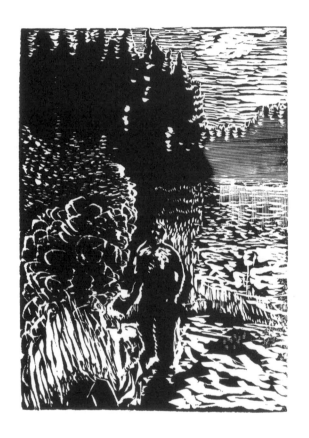

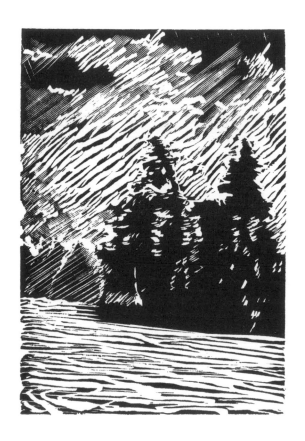

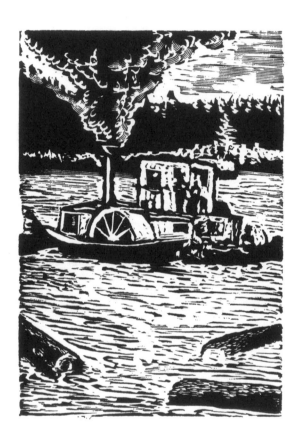

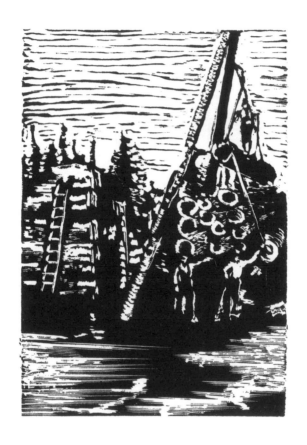

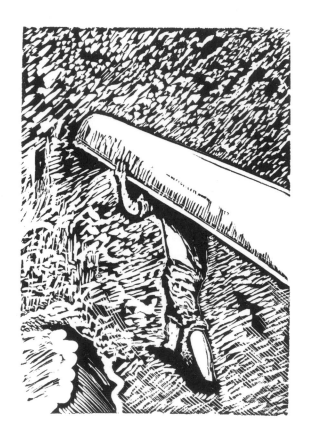

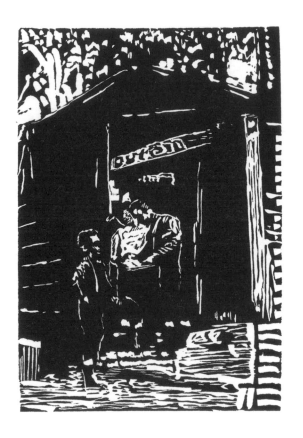

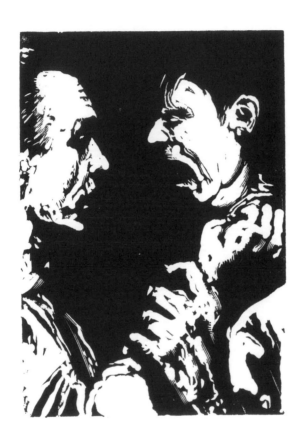

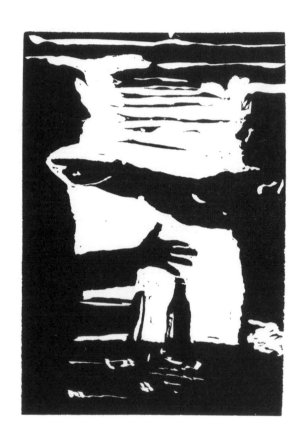

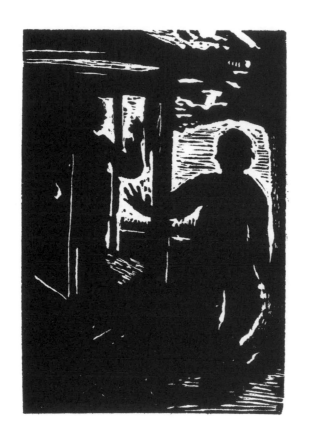

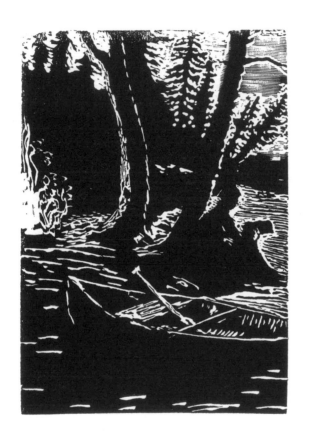

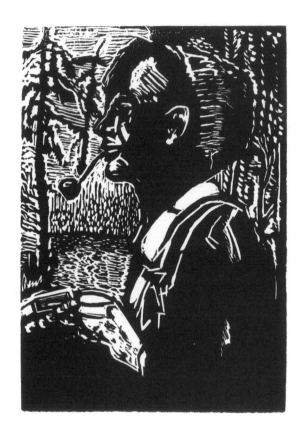

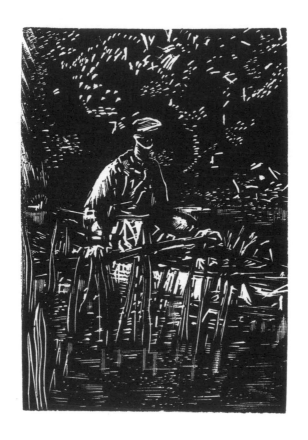

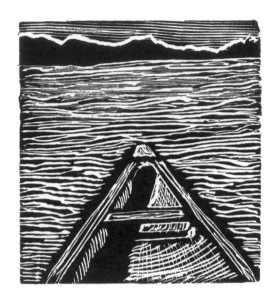

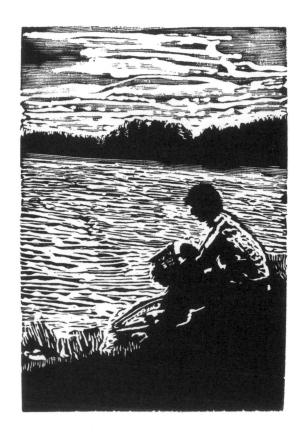

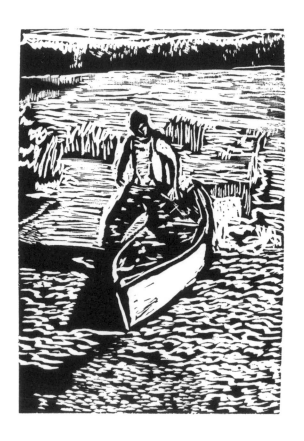

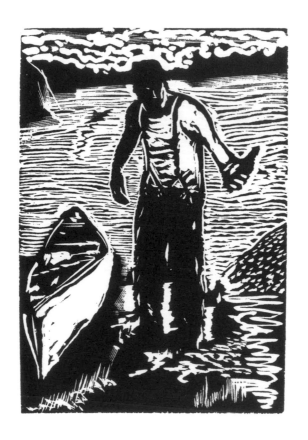

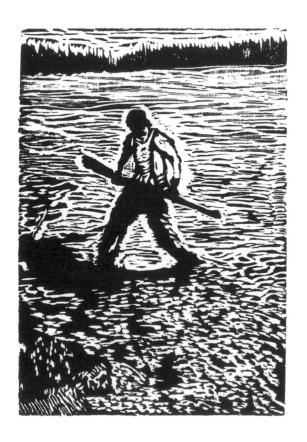

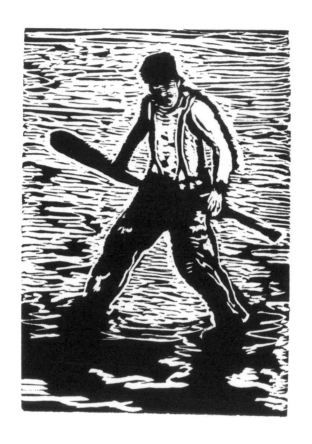

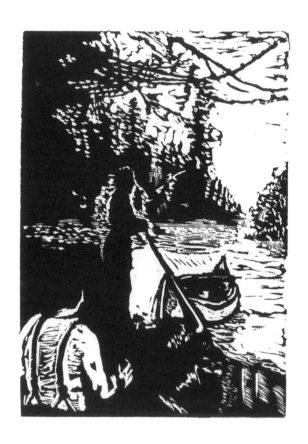

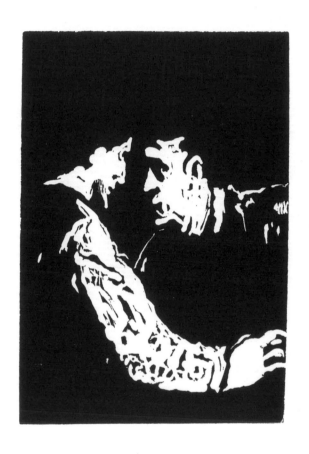

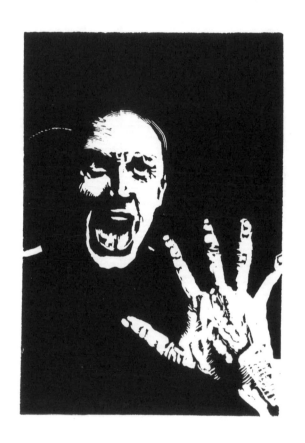

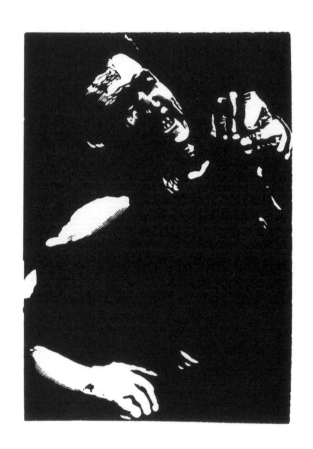

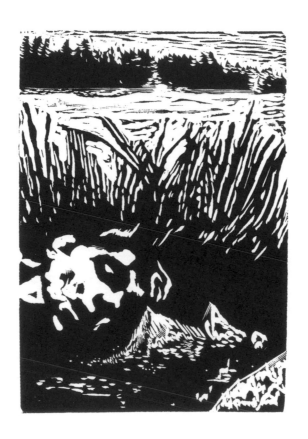

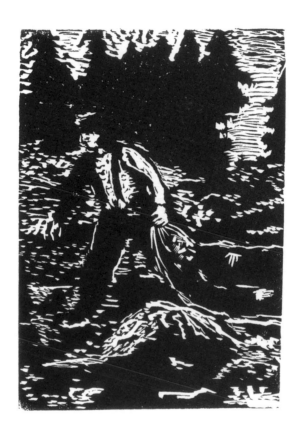

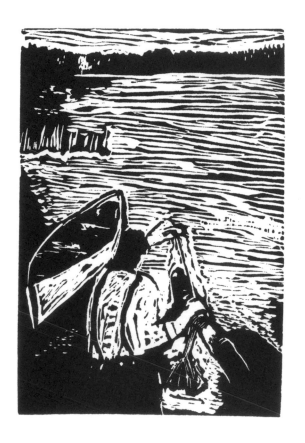

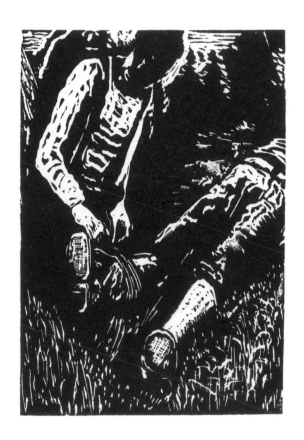

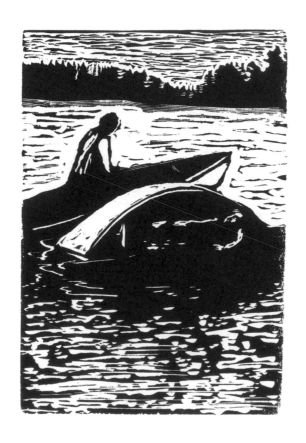

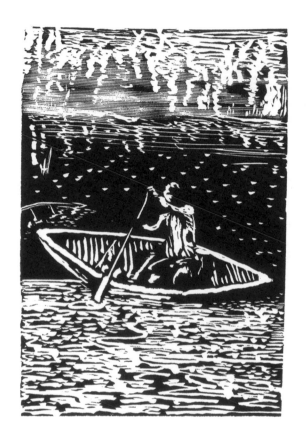

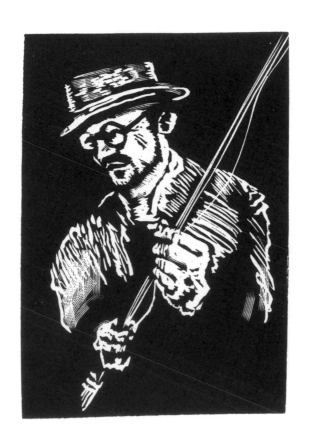

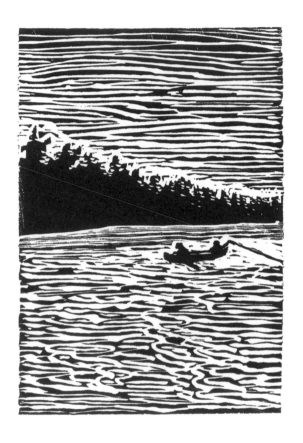

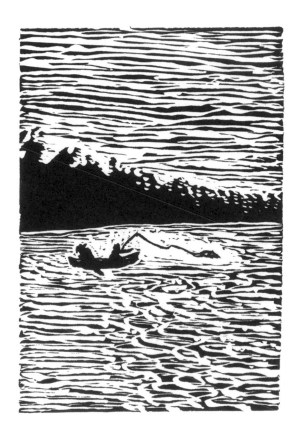

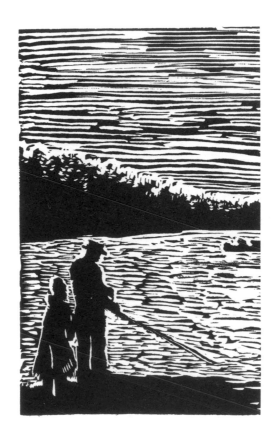

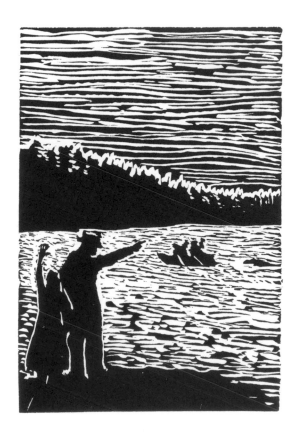

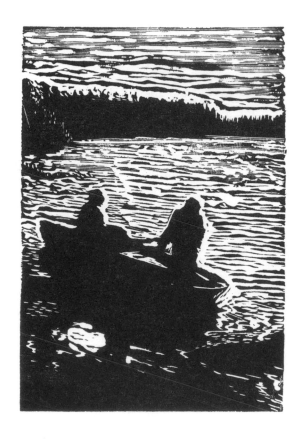

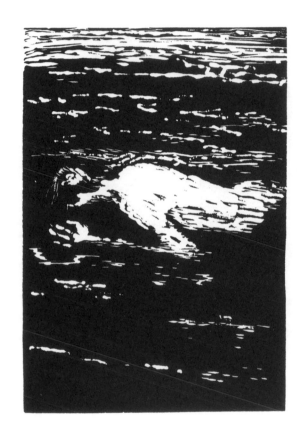

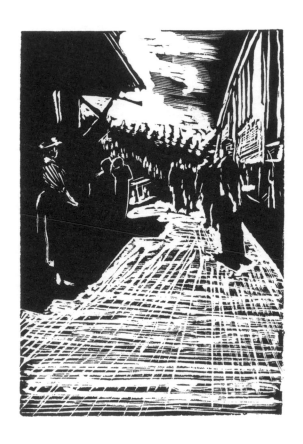

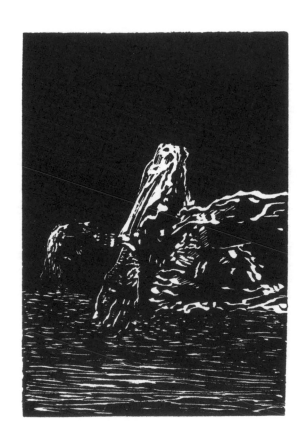

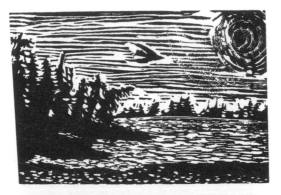

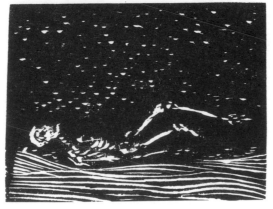

AFTERWORD

GEORGE A. WALKER

We all 'read' a vast array of images that present themselves to our attention daily. Our world is filled with signs and symbols. Our distant ancestors once read the stars as a compass, and we still study the sky to forecast weather. The surface of the ground at our feet can tell an experienced tracker just who or what may be prowling in the vicinity. The earliest cave paintings were inspired by the interactions between humans, animals and the world they shared. These sorts of natural signs and signifiers provided the basis for what would eventually become a multitude of written languages. Our essential need to preserve and to communicate our stories has evolved into a complex system of writing that is rooted in the simplicity of the pictogram. Presented thoughtfully, pictures can still convey information, evoke pleasure or warning, influence behaviour and, most important, tell a story.

The Mysterious Death of Tom Thomson is the second of my wordless narratives, based on original hand-printed limited editions, to be published by the Porcupine's Quill. In it I tell the story of the Canadian painter and cultural icon Tom Thomson (1877–1917). There is no shortage of art historians who recognize Thomson as a key influence on the Group of Seven, founded in 1919, and instrumental in the shift of Canadian art towards modernism. Most Canadians, however, know of him from the enduring mythology surrounding his short life and the curious circumstances of his death.

It has often intrigued me that Thomson chose to avoid depicting the industry that surrounded him in the city;

though, admittedly, a clearly art-nouveau urban approach does appear in the commercial work that he produced for the Toronto design firm Grip Ltd. Canada was undergoing dramatic changes during Thomson's lifetime, and the artist found himself working in the midst of an industrial landscape cluttered with machines and booming population growth – all coloured by the mounting tensions that would lead to the First World War. Rather than document the grim realities of industrialization, Thomson set out to discover and depict the untamed wilderness of Northern Ontario. Through Thomson's impressionistic style, the paintings from this period communicate the harshness of the Canadian landscape as well as Thomson's steadfast love of a land now threatened by the rise of industrialization. It is Thomson's unceasing search for the definitive expression of an emotionally charged landscape that appeals most to us in his legacy. I hope it is deemed appropriate that such an artist, who rarely wrote a word but painted and sketched hundreds of images, will have his story retold in the language he understood best: the language of pictures.

As images supply the means of communication in this book, an understanding of the process of engraving is critical to an appreciation of the medium. I tell the story of *The Mysterious Death of Tom Thomson* through one hundred and nine engravings carved into handmade blocks of wood. Wood engraving and woodcut were techniques favoured by the German Expressionists, many of whom were active around the time Thomson was painting. Though Thomson himself seems to have expressed little interest in art theory, his paintings clarify that he did hold some of the same beliefs as the Expressionists who sought to articulate emotional meaning through a primal response in their art.

In addition to the obvious connection between Thomson

and wood engraving, all of the images in this biography were carved into blocks I manufactured myself from Canadian maple. Wood is an organic material, part of the natural world that Thomson depicted in his landscapes, and like the woodlands he painted it speaks to the artist through the idiosyncrasies it retains, the knots and anomalies buried in the block's rings of time. The tree I used to make the blocks was very likely alive when Thomson was painting in Algonquin Park where part of this story is set. To strengthen the connection between the story of Thomson and the medium used to tell it, my friend Tom Smart presented me with some decaying branches that he believes fell from the trees Thomson painted in *Byng Inlet*. I took these branches and fashioned them into the block that I used to make the last image in the book.

One final note: I should mention that I've divided the narrative into two parts, that of the city and that of the country, to mirror the reality that Thomson led two distinct lives, a duality that was important in both his art and his personal life. When Thomson left the city to live in the hinterland of Northern Ontario, he became fully immersed in the life of the backwoodsman. Abandoning his city life and his commercial artist's work at Grip, he was transformed. His patron, Dr. James MacCallum, has commented that, 'Thomson had but one method of expressing himself, and that one was by means of paint'. (MacGregor, *Northern Light: The enduring mystery of Tom Thomson and the women who loved him.*)

For myself I believe the body of Tom Thomson still rests at Canoe Lake, and it is also my opinion that the true story of the Tom Thomson tragedy will never be known. Thomson lived, painted, loved and died under a veil of mystery and to this day, stories of Thomson's ghost still circulate in Algonquin Park. What does remain of Thomson now is a potent body of work that defines a moment in time and one man's

vivid engagement with nature. My hope is that I have succeeded in communicating some of the same passion in my visual narrative that Thomson achieved in paintings such as *The Jack Pine* and *The West Wind*.

ABOUT THE ARTIST

George A. Walker is an award-winning wood engraver, book artist, teacher, author, illustrator and publisher who has been creating artwork and books at his private press since 1984. Walker is an associate professor at OCAD University in Toronto, where his popular courses in book arts and printmaking have been offered continuously since 1985. For over twenty years Walker has exhibited his wood engravings and limited edition books internationally, often in conjunction with the Loving Society of Letterpress (and the Binders of Infinite Love) and the Canadian Bookbinders and Book Artists Guild (CBBAG). Among many book projects, Walker has illustrated two hand-printed limited editions written by Neil Gaiman, the acclaimed author of comic books, film scripts, short fiction, novels and song lyrics. Walker also illustrated the first Canadian editions of Lewis Carroll's *Alice's Adventures In Wonderland* and *Alice Through the Looking-Glass* published by Cheshire Cat Press. George Walker was elected to the Royal Canadian Academy of Art in 2002 for his contribution to Book Arts.